Frank Moore

PAINTINGS

28 March–25 April 1998

SPERONE WESTWATER
NEW YORK

1998 © Frank Moore and Sperone Westwater, New York
Printed in the United States of America by
Thorner Press Inc., Buffalo, New York

To
Paolo Alberto Paciucci

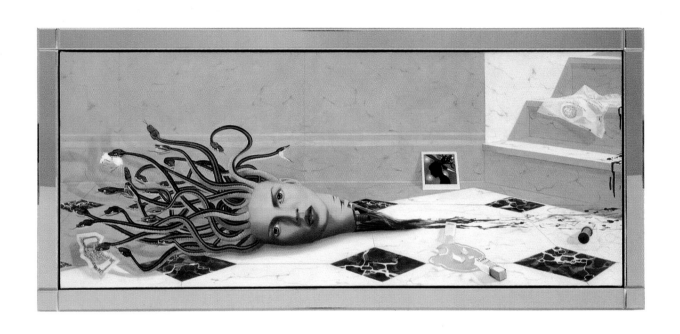

To Die For, 1997

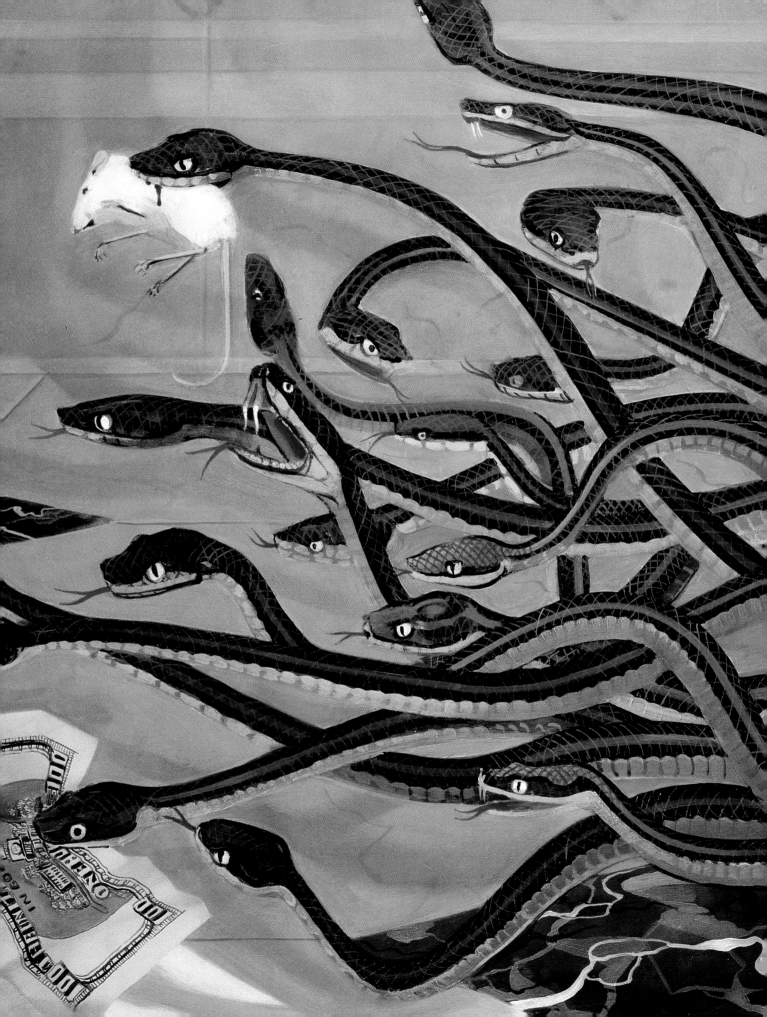

Free For All, 1997–98

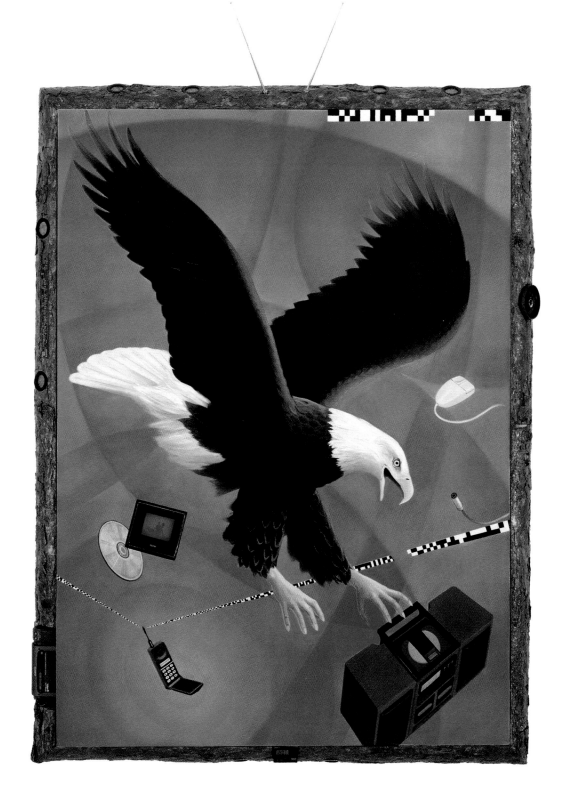

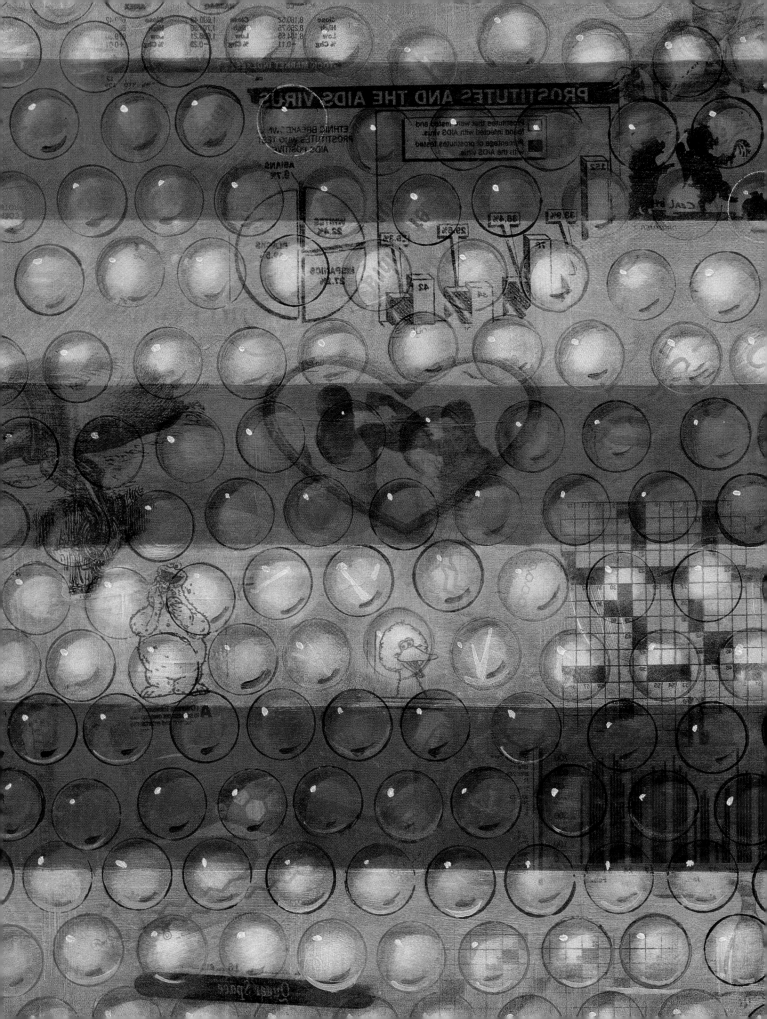

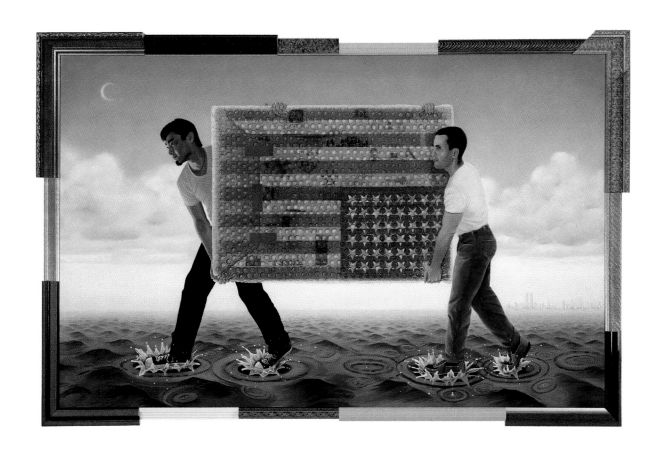

Emigrants, 1997–98

Angel, 1996

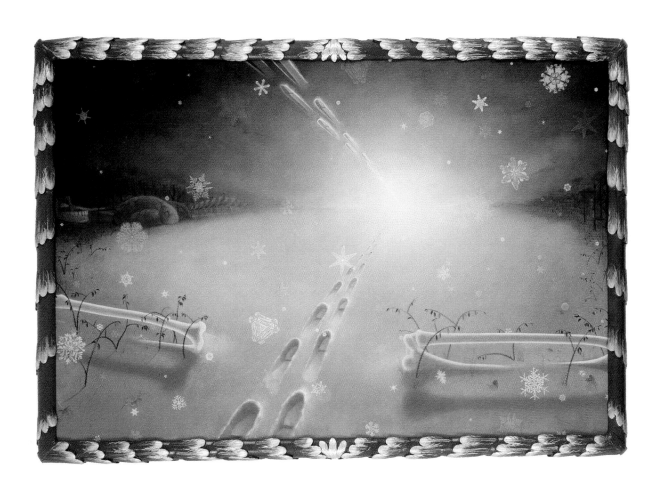

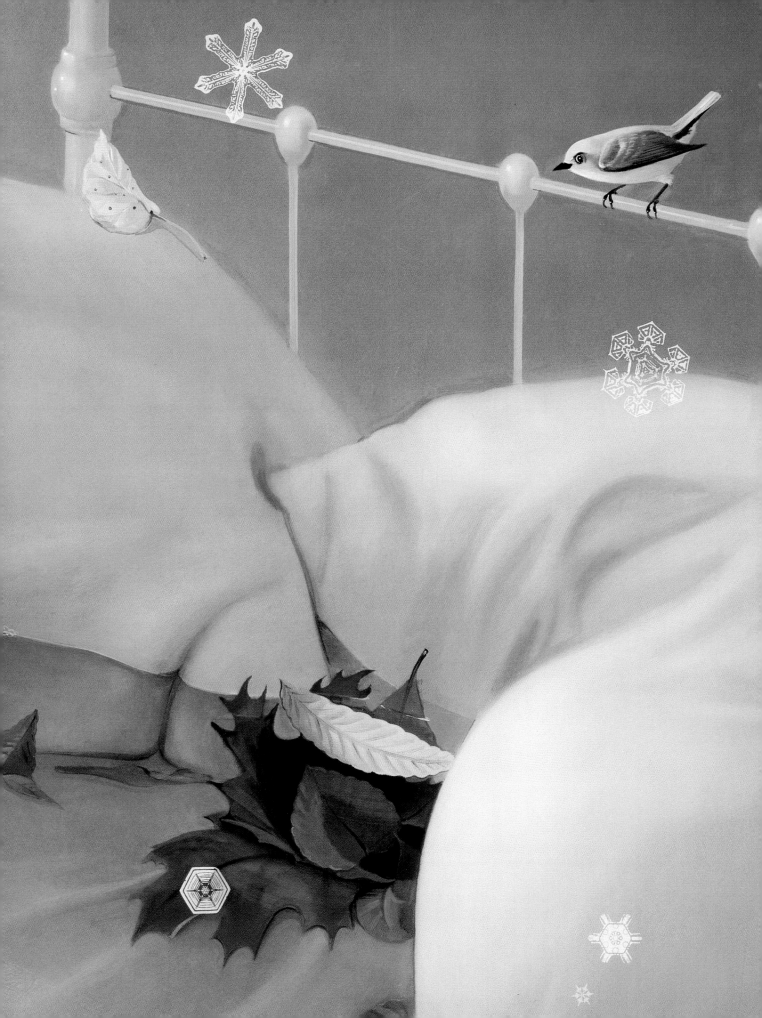

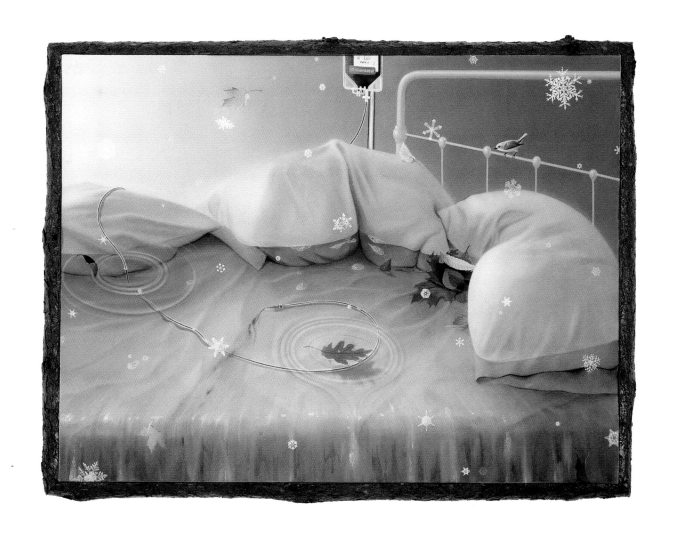

Patient, 1997–98

Lullaby, 1997

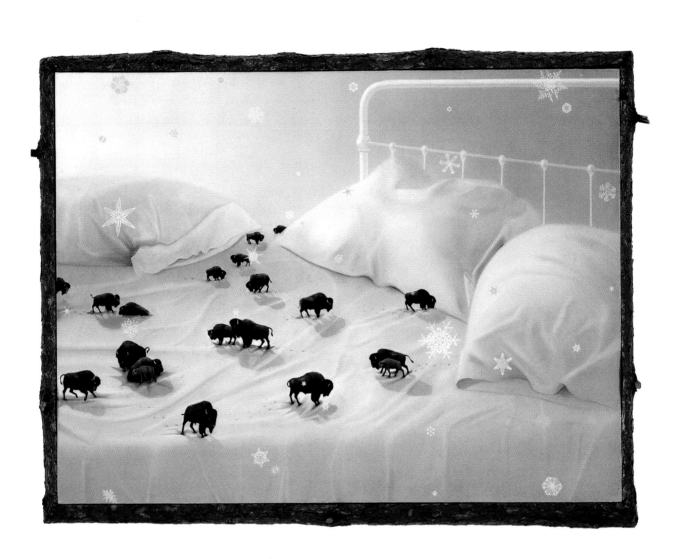

Lullaby II, 1997

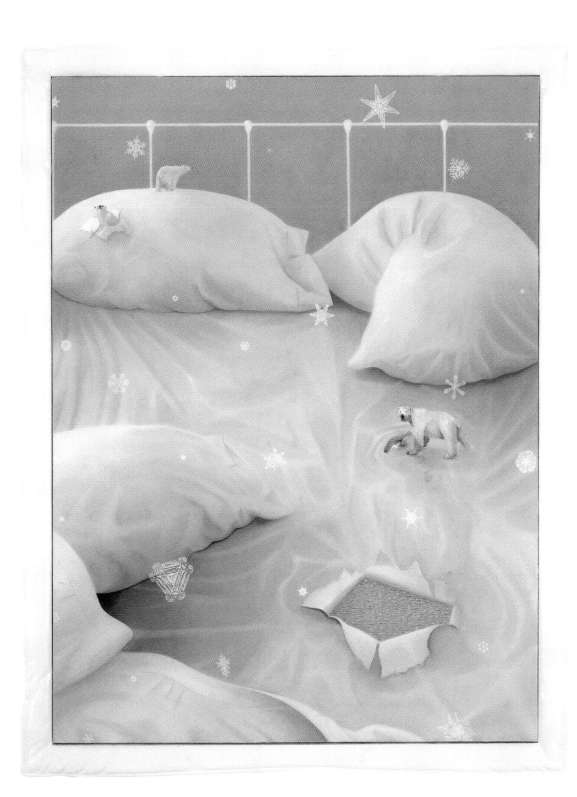

Jacques and Tyrone, 1997

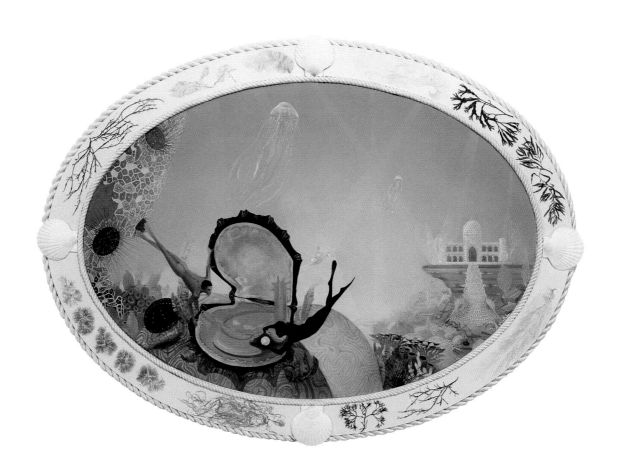

Bearded Clam, 1997

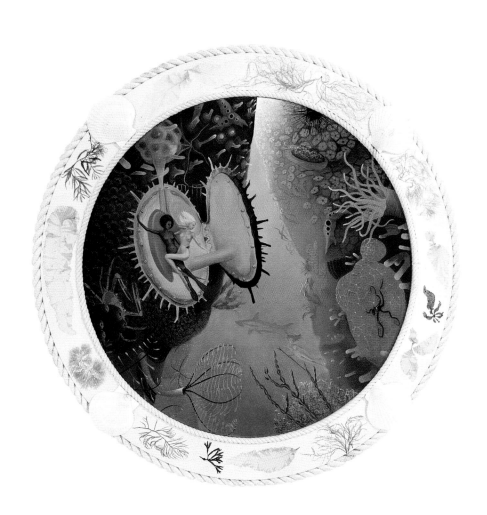

Aquarium, 1997

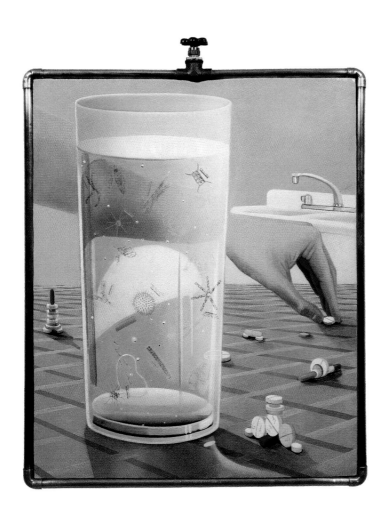

Missing Links, 1997

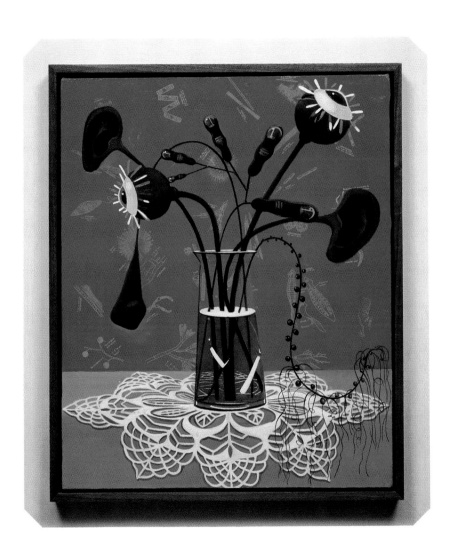

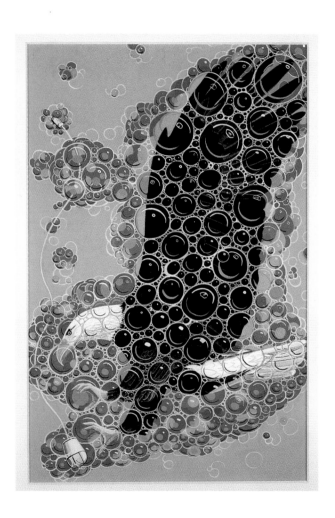

Study for 'Free For All', 1997
gouache

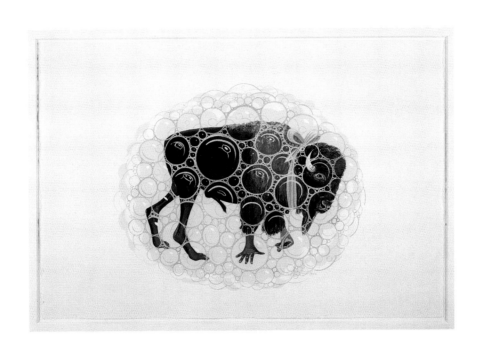

Clean Clone, 1997
gouache

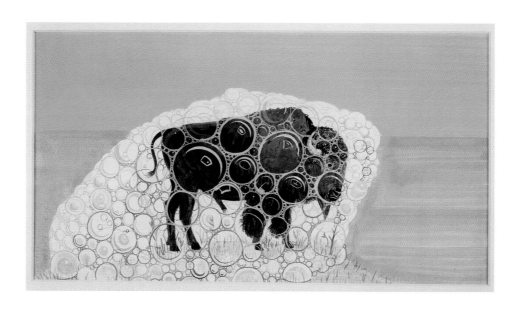

Squeaky Frontier, 1997
gouache

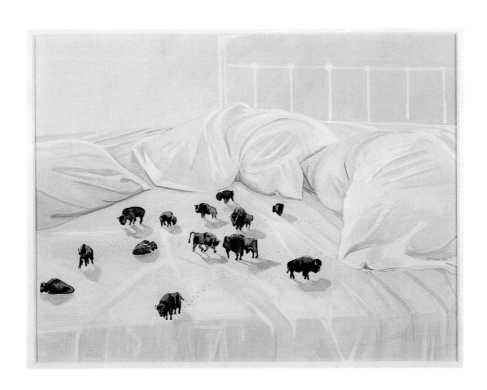

Study for 'Lullaby',1997
gouache

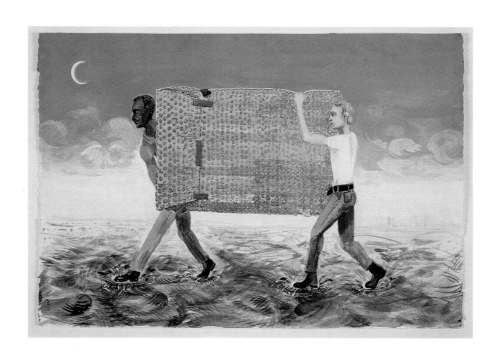

Study for 'Emigrants', 1997
gouache

List of Works in the Exhibition

PAINTINGS

To Die For, 1997
oil on canvas on featherboard with mirror frame
27³/₄ x 61⁵/₈ inches (70.5 x 156.5 cm.)

Free For All, 1997–98
oil on canvas on featherboard with electronic
surveillance system with red pine frame and mixed media
66 x 50 x 4 in. (167.6 x 127 x 10.2 cm.)
73 x 50 x 4 in.(185.4 x 127 x 10.2 cm.)w/antennae

Emigrants, 1997-98
oil on canvas on featherboard with frame
68 x 104 inches (172.7 x 264.2 cm.) overall

Angel, 1996
oil on canvas on featherboard with cast silver leaf frame
55 x 81 x 2⁵/₈ inches (139.7 x 205.7 x 6.7 cm.)

Patient, 1997–98
oil on canvas on wood panel with red pine frame
49¹/₂ x 65¹/₂ x 3¹/₂ inches (125.7 x 166.4 x 8.9 cm.)

Lullaby, 1997
oil on canvas on featherboard with red pine frame
50 x 65 inches (127 x 165.1 cm.)

Lullaby II, 1997
oil on canvas on featherboard with painted carved
wood frame
68 x 51¹/₂ inches (172.7 x 130.8 cm.)

Jacques and Tyrone, 1997
oil on canvas on featherboard with aluminum frame with
seaweed, nylon rope & scallop shell attachments
44³/₄ x 61¹/₂ inches (113.7 x 156.2 cm.)

Bearded Clam, 1997
oil on canvas on featherboard with aluminum frame with
seaweed, nylon rope & scallop shell attachments
41¹/₂ inches diameter (105.4 cm. diameter)

Aquarium, 1997
oil on canvas on featherboard with half-inch copper
plumbing pipe with valve
28¹/₂ x 22¹/₄ inches (72.4 x 56.5 cm.) overall

Missing Links, 1997
oil on canvas on featherboard with two-tone wood frame
27¹/₂ x 23¹/₂ inches (69.8 x 59.7 cm.)

WORKS ON PAPER

Study for 'Free For All', 1997
gouache and watercolor on paper
22 x 14³/₄ inches (55.9 x 37.5 cm.)

Clean Clone, 1997
gouache and watercolor on paper
15 x 22¹/₂ inches (38.1 x 57.2 cm.)

Squeaky Frontier, 1997
gouache and watercolor on paper
11¹/₂ x 22 inches (29.2 x 55.9 cm.)

Study for 'Lullaby', 1997
gouache and watercolor on paper
14¹/₂ x 19¹/₂ inches (36.8 x 49.5 cm.)

Study for 'Emigrants', 1997
gouache and watercolor on paper
15 x 22¹/₂ inches (38.1 x 57.2 cm.)

SPERONE WESTWATER
142 Greene Street New York 10012
212-431-3685 (fax) 941-1030